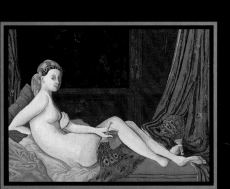

PENGUIN BOOKS

Great Housewives of Art Revisited

Sally Swain was born in 1958 in Sydney. At age three she painted people with large belly buttons. At age five she began keeping an illustrated journal. She later graduated in psychology and art history, then worked as a research assistant, a youth worker, a teacher and a waitress.

In 1985 Swain focused on painting and illustration, and in 1986 the first few Great Housewives of Art frolicked into the world for an exhibition, "Mabel Stays at Home."

Swain's first book, "Great Housewives of Art" (Grafton/Doubleday, 1988; and Viking Penguin, 1989), received international acclaim, yet she still hesitates to write on competition entry forms Occupation: Artist.

Her house could be cleaner.

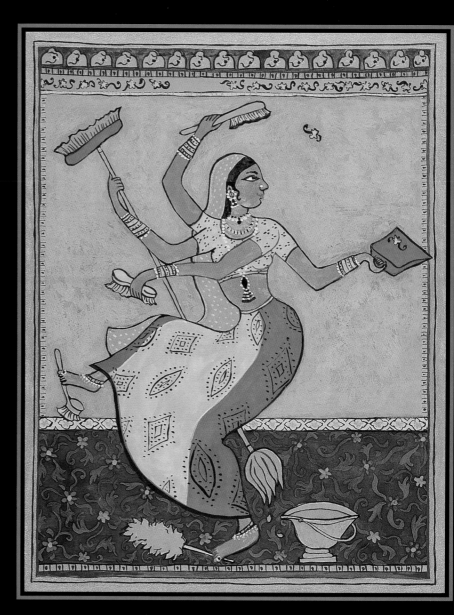

PENGUIN
BOOKS

GREAT HOUSEWIVES OF ART

Revisited

SALLY SWAIN

PENGUIN BOOKS

Published by the Penguin Group

Viking Penguin, a division of Penguin Books USA Inc.,

375 Hudson Street, New York, New York 10014, U.S.A.

Penguin Books Ltd, 27 Wrights Lane, London W8 5TZ, England

Penguin Books Australia Ltd, Ringwood, Victoria, Australia

Penguin Books Canada Ltd, 10 Alcorn Avenue, Suite 300,

Toronto, Ontario, Canada M4V 3B2

Penguin Books, (N.Z.) Ltd, 182-190 Wairau Road, Auckland 10, New Zealand

Penguin Books Ltd, Registered Offices: Harmondsworth, Middlesex, England

First published in Penguin Books 1992

10 9 8 7 6 5 4 3 2 1

LIBRARY OF CONGRESS CATALOGING IN PUBLICATION DATA
Swain, Sally.
 Great housewives of art revisited / Sally Swain.
 p. cm.
 ISBN 0 14 01.5837 5
 1. Artists' wives—Caricatures and cartoons. 2. Australian wit and humor, Pictorial. I. Title
NC1759.S93A4 1992
741.5'994—dc20 91–27937

Printed in Singapore

Set in Berkeley Old Style
Designed by Kate Nichols

*F*or

Iris, David, Jennie, Stuart

and the spirit of my grandmother,

Millie

Thank you to Mum, Dad, Jen and Stu for your sensitivity, support, encouragement, brilliance, astute suggestions, ruthless criticism and most of all— love.

Thank you to my friends for their warmth, closeness, respect and for being there—in particular Estelle, Barbara and Stefan for help with words and photography.

Thank you to my agents and publishers.

INTRODUCTION

ou see me, but you don't see me. I am everywhere, but nowhere. Who am I?[1]

I have been painted over and over,
as madonna, virgin, mother, wife;
as temptress, witch, monster;
as goddess and passive nude love object.

You see me. I am everywhere.
Painted in stereotype. Projected male fear, desire, fantasy.

But you don't see me. I am nowhere.
I am invisible as subject.
My experiences, feelings, ideas, activities—invisible.

I am invisible as domestic laborer. My care of man, child, environment—
life-sustaining, but unseen.

I am also invisible as artist. My expression has been diminished, overlooked, suppressed. Sometimes my work is claimed as his work. I do the work; he gets the credit. He creates high art; I dabble in the minor arts. He is artistic genius; I am mother and wife.

You see me, but you don't see me. I am visible, but disguised.
Who am I?[2]

I paint, I write, I parody. I do not alter prints of famous artworks—
I reconstruct them and paint each and every brushstroke, using the language
of great artists.

Here, I strive to redraft art history; to paint woman into the picture.

You see *me*. I am everywhere.
Who am I?[3]

I am experiencer, senser, acter, interacter.
I do ordinary things—I scrub, line up, park the car.
I do extraordinary things—I perform miracles, create the universe.
I cook, clean, support, nurture, make things nice.
I love, share, struggle, forget, relax, get fit, get angry, get aware, take control.

Here I am.

1. I am the image of woman in art history.
2. I am Sally Swain.
3. I am a Great Great Housewife of Art.

Great Housewives
of Art Revisited

PALEOLITHIC

Each Stone age husband must engrave
and paint a bison in his cave.

This prehistoric Altamira
rock art draws the dinner nearer.

Stone Age housewives can divide
and cook the bison with this guide:

Be lavish with the herb and spice on
number one—scrag neck of bison.

Wise and thrifty cave householders
stew cut number two—the shoulders.

Simmer well to best digest
cut number three—the flank or breast.

The belly, number four, you braise
and serve with mammoth
 mayonnaise.

Cut five, most choice from bison
 plump,
is grilled as juicy loin or rump.

And six, the leg, you barbecue
with dash of totem and taboo.

They cook by numbers with a chart
that's functional, but *is it art*?

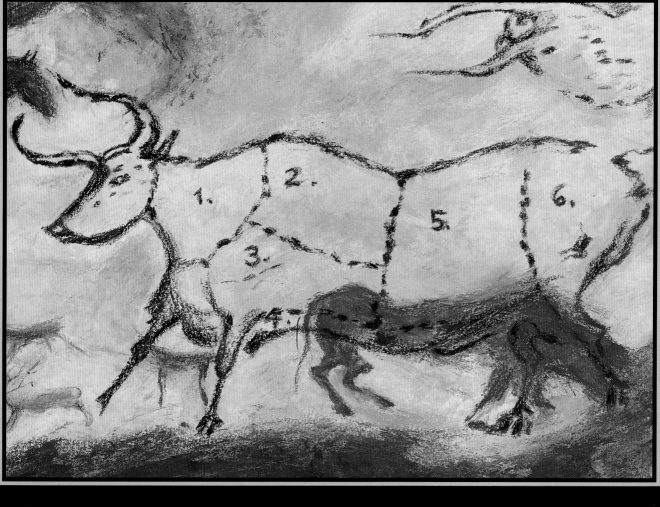

Paleolithic Cooking Guide

ABORIGINAL AUSTRALIAN

When seized by gastronomic wish
that grows into a craving
for chargrilled kangaroo or fish,
consider microwaving.

Avoid "old oven" stigma
and the slowness of combusting.
New ovens have enigma,
plus more buttons for adjusting.

The how and why of microwaves
continues to perplex.
This oven, *some* believe, behaves
by beaming rays of x.

The X rays also function
as a style of art. You view
the guts, without compunction,
of a see-through kangaroo.

You close a door, a tray revolves—
entrancing carousel.
But everything alive dissolves
in organismic hell.

Fans stir, autos defrost, you touch
controls for who knows wattage.
Tradition rich is lost within
the electronic cottage.

This intelligent appliance
your recipes remembers,
but you leave your self-reliance
in glowing fireplace embers.

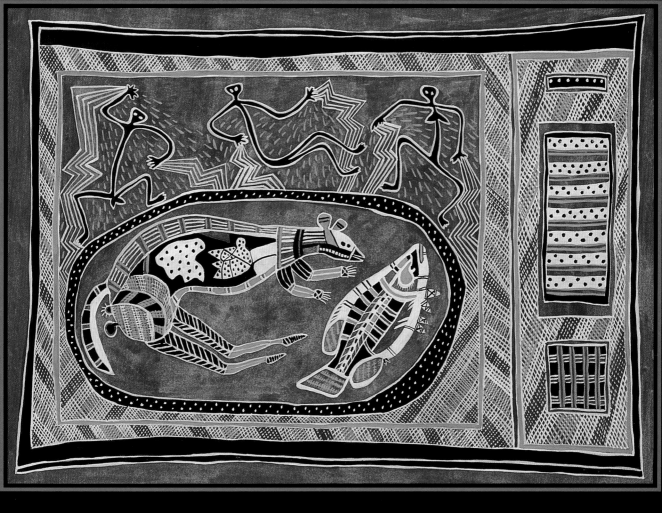

Microwave Dreaming

EGYPTIAN

We old Egyptian postal workers
serve with sideways smile,
our eyes and chests in frontal view,
the rest in strong profile.

If you wish to buy a stamp
or post the Sphinx a riddle,
all kingdoms will be catered for—
the old, the new, the middle.

In place of ritual offerings,
why not employ a drafter
of arty correspondence for
a soul in the hereafter.

A telephonic telegram's
not visually terrific.
You may prefer a pictogram—
come in and hire a glyphic.

For those environmentalists
of envelopes desirous,
we use recycled, safe, bio-
degradable papyrus.

All packages should indicate
their contents with description
like "Cleopatra's deadly asp—
it's ancient and Egyptian."

And if your mummy's heavenbound
in ugly old pajamas,
please call our special mailroom staff
who double as embalmers.

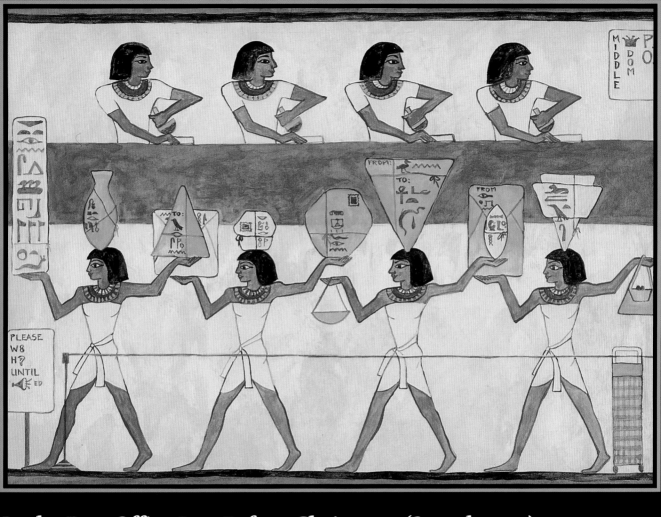

In the Post Office Just Before Christmas (3 weeks B.C.)

after Egyptian tomb paintings,
c. 2000–1500 B.C.

GREEK

Battle of the Sexes
Classical Knits

Knit your husband a toga in the latest sixth century B.C. up-to-the-minute designs—"Athena slays Enceladus," "Hera strangles Zeus" and "Psyche confronts Eros." There's nothing Spartan about these ideal knits of Truth, Beauty and Simplicity.

Tension
Carry out a tension check before commencing garment. If your knuckles are white, you are too tense. If you drop your spear, you are too relaxed.

Knitting abbreviations
K = knit
K2tog = knit two togas
P = pose heroically
sl = slip
st = stumble
sp = spear (him *now*, or you'll be ancient history)

Yarn quantities
Colossal

Measurements
Olympian

Instructions
Mythical

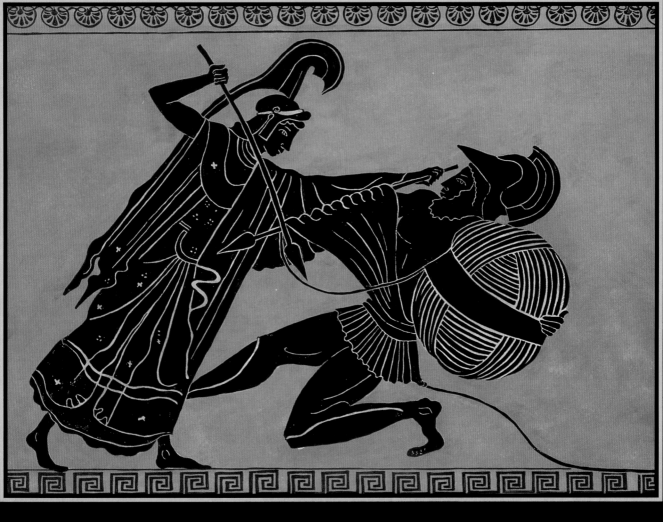

Athena Knits a Toga

MEXICAN

Our astonishing contraceptive devices double as party entertainment aids.

1. *Condom or Raincoatl*
 For safe xex. Optional quetzal feathers. Also use as balloon.

2. *Xintrauterinals*
 Moderately ineffective and quite unsafe
 a) Coil: With ring pull. Now available in jaguar or ocelot skin. Also use as firework.
 b) Pretzelcoatl: Pull string in case of human sacrifice to sun god. Also a savory party snack.
 c) Snake: Poisons unwanted sperm. Also functions as bottle opener.

Quetzalcoatl Pharmacy Contraceptive and Party Goods Sale

3. *a) Cap or Ovacoatl:* May leap across room if not controlled. Also functions as headwear. Use in conjunction with:
 b) Contraceptive Jelly
 Which also makes a tasty dessert.

4. *Pill*
 28-Dot calendar-friendly contraception. 98 percent effective. Side effects include nausea, loss of libido, giddiness and death. Also use as candy.

5. *Multifunction Super Gadget*
 Chops, dices, slices, purées, peels, stops pregnancy and takes out the garbage.
 Also mixes a mean cocktail.
 Effectiveness: none. Safety: none.

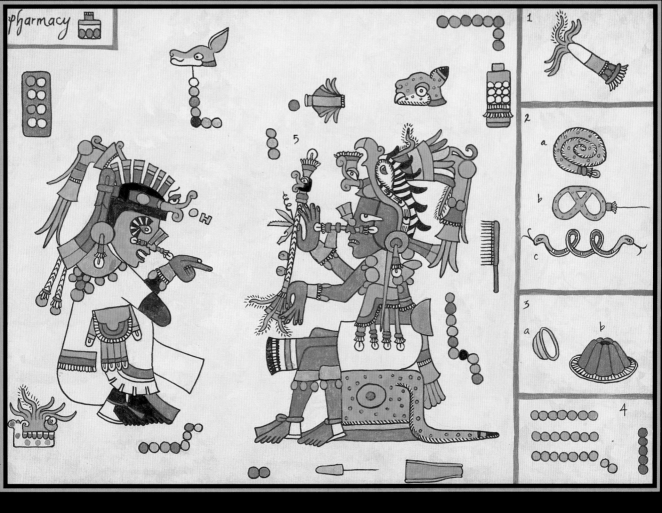

Which Contraceptive Device?

INDIAN

Sweepa
Goddess of Housework
and Purity

Legend has it that Mukna the Filth Monster tried to overpower Sweepa by living everywhere that humans trod. He created a land mass of rotting vegetables, toenail pickings, industrial refuse and teapot mold.

But Sweepa grew two extra arms. She turned the sea into foaming laundry detergent and mopped and dusted and scoured until the world was gleaming once again.

However, now that she had started cleaning, she could not stop. Unbeknownst to Sweepa, her jealous husband Opresh, God of Business and Enterprise, had cast a spell. He wanted to ensure Sweepa stayed home and didn't go off to university where she would learn about the world, become dissatisfied with her lot and meet a nice young educated virile god. So Opresh decreed that once Sweepa began cleaning she would be doomed to eternal housework. If ever she abandoned her duty, Mukna the Filth Monster would swallow up Sweepa and then the entire world.

That is why to this very day, Sweepa and her daughters and her daughter's daughters wash and polish and wipe and scrub eternally, endlessly and forever.

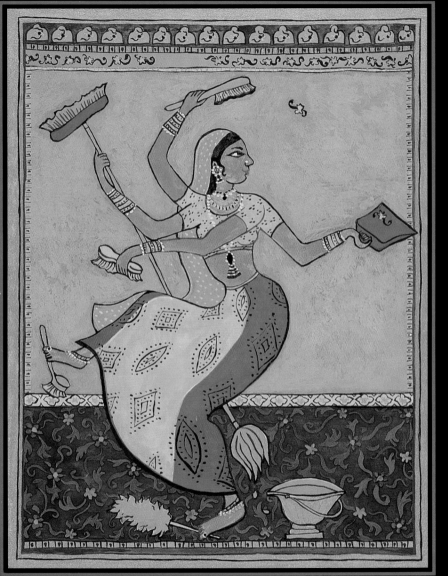

An Indian Goddess's Work Is Never Done

after Indian miniatures,
c. eighteenth century

JAPANESE

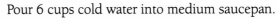

1. Pour 6 cups cold water into medium saucepan.
2. Gently stroke face and body of lover. Add small amounts scratching and biting.
3. Bring water to a boil.
4. Pour 2 cups rice into boiling water. Stir with chopstick.
5. Partially remove kimono. Allow him to caress your body. Sigh sporadically.
6. Yawn daintily while entry takes place. Remain demure.
7. Turn down heat. Simmer for 20 minutes, stirring occasionally.
8. After climax, clean up mess.
9. Drain and serve.

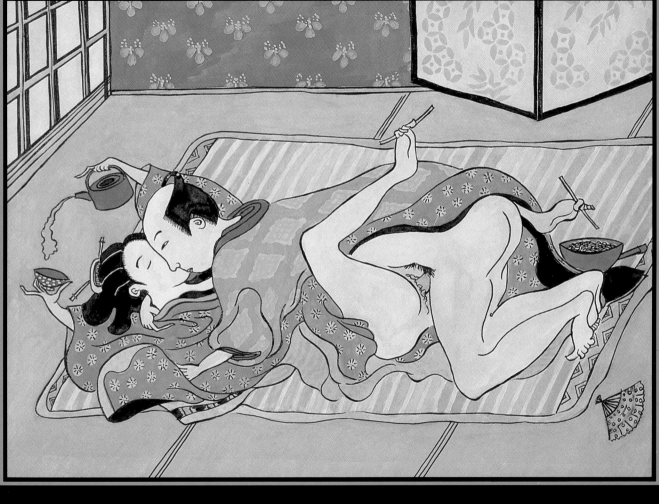

The Art of Japanese Erotic Cookery

BYZANTINE

Party Miracles
at Magic Prices

*T*rick	Cost
	(in gold coins)
loaf—white	2
—wholemeal	3
fish—dead	5
—alive	6
water to lemonade	10
water to wine (adult parties only)	15
walk across swimming pool—kiddies' pool	20
—Olympic	25
disabled to able-bodied	30
blind to sighted	35

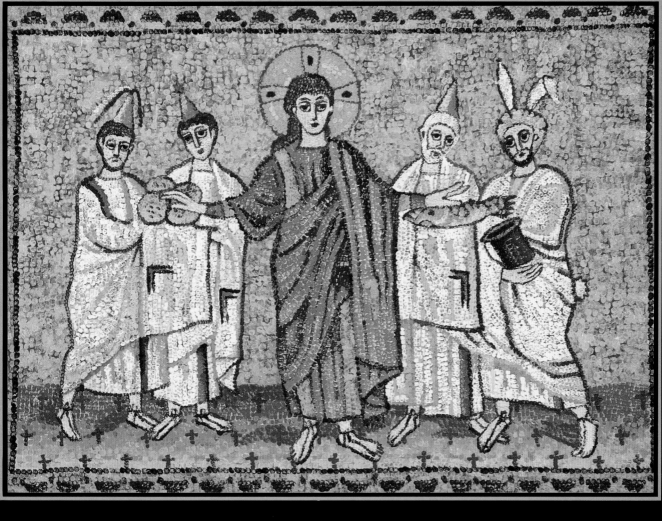

Party Tricks to Amuse the Kids for Hours

LINDISFARNE GOSPELS

Housewife's Revenge

Her husband's bathroom rituals
were more than she could bear.
He squeezed the toothpaste from the
 top
and caked the soap with hair.

The hair was of the pubic kind—
 curly, black and short;
a paradise attracting germs
to revel and cavort.

His soggy towel adorned the floor,
entwined with dental floss.
A fungal jungle filled the bath.
The shower sprouted moss.

The toilet seat stood vertical.
Its lid stayed upright too.
He splashed with yellow pungency
and *never* flushed the loo.

Unsanitary conduct drove
this housewife to distraction.
Spurred on by slime, she found the time
to launch a plan of action.

She baked a casserole of hairs.
His towel she dropped in bed.
The toothpaste tube she filled with glue.
They are no longer wed.

If Only He Wouldn't Leave the Cap Off the Toothpaste

after Cross Page from *Lindisfarne Gospels*, Irish illuminated manuscript, c. 700 A.D.

BAYEUX TAPESTRY

Hastings Hypermart Parking Lot

Fees

First 2 hours—free

Third hour, or part thereof—one suit chain mail

Fourth hour, or part thereof—one suit chain mail plus one Norman (conquered)

Over 4 hours—one suit chain mail, one Norman (conquered), an arm and a leg.

Rules and Regulations

- Validate your shield
- Overtake other drivers—or they'll beat you to this week's specials
- Remove spears from shopping carts before returning them to Bayeux
- Tether horses, anchor and lock ships.
 Proprietor not liable for injury, loss or damage (with exception of arrow through eye) to any person or vehicle, notwithstanding any act, omission or attack on the part of the proprietor.
- No oath-swearing permitted, Harold excepted.

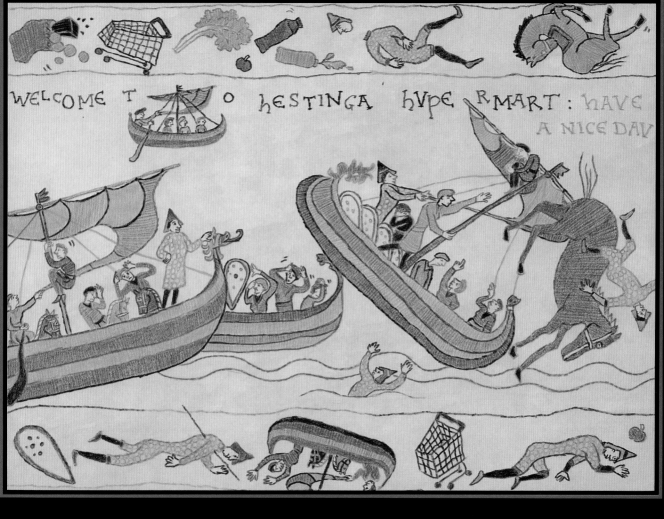

The Battle of Hastings Hypermart Parking Lot

DUCCIO

Instructions follow here, describing
how to change, with honor
and reverence, a diaper soiled by
offspring of Madonna.

Inhale at risk of spoiling your
expression sweet and tender.
Disgust or even faint distaste
are not on the agenda.

Get talcum powder, bucket,
diaper fresh and safety pin.
Wash hands to stay immaculate
of concept and of skin.

Now, call a band of angels
for, unless you're fond of scandal,
certain things, however holy,
icons must not handle.

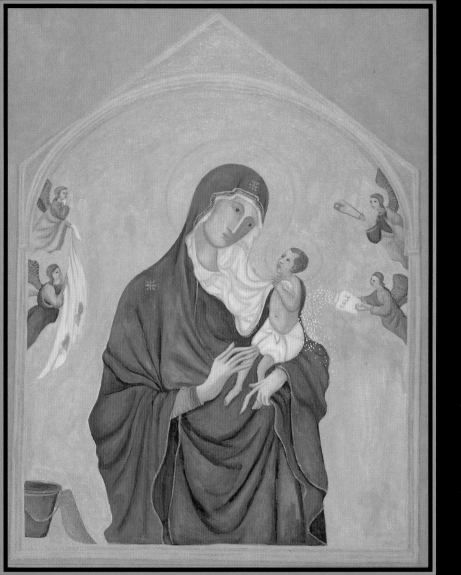

Mrs. Duccio
Changes a Diaper

after Duccio di Buoninsegna
*The Virgin and Child with
Saints Dominic and Aurea*,
tabernacle, c. 1300

GIOTTO

Mrs. Giotto, housewife and mother of at least six, heralds the new Halo dish drying method:

"You can't do better than this glorious technique. It's fast, efficient and stacks of fun for the whole family.

I used to dry up alone and be constantly drained. Now I've discovered the Halo method—a real blessing.

No longer do I urge the children to help with the dishes. After dinner they soar from the table, wash up, place plates and cutlery on their angelic little heads, and take wing."

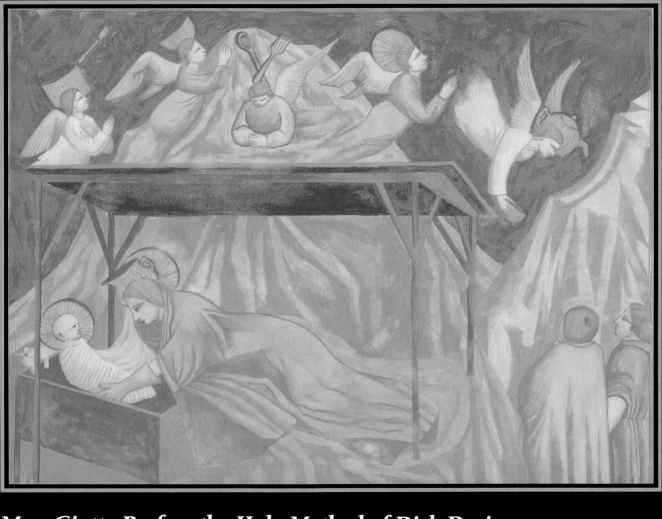

Mrs. Giotto Prefers the Halo Method of Dish Drying

after Giotto's *Nativity*, fresco,
Arena Chapel, Padua, 1302–5

MASACCIO

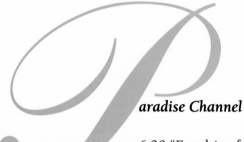

TV Program

Paradise Channel

6:30 "Expulsion from Eden Street" (soap opera) (repeat) (PGR)
Tonight's episode :
Mr. and Mrs. M. commit dreadful, although quite original, sin.
Mrs. M. forgets to collect laundry. Hapless couple parade naked through
neighborhood, wearing nothing but badly painted foliage.
The Masaccios banished forever from Eden St.

Next week :
Mr. M. begets Cain and Abel.

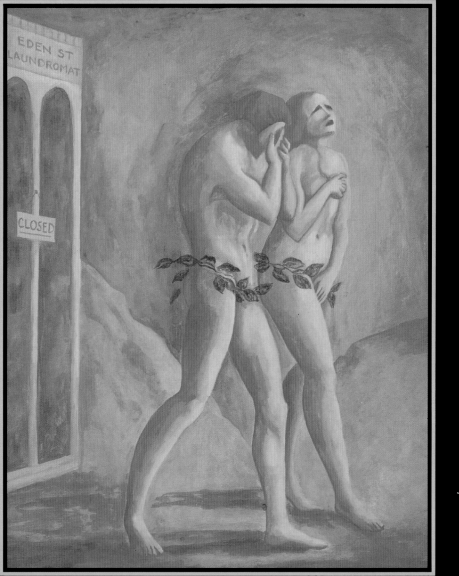

Mrs. Masaccio Forgets to Pick Up the Laundry

after Masaccio's *The Expulsion from Eden*, fresco, Brancacci Chapel, Florence, c. 1427

VAN EYCK

M en!
You can change the world by changing yourself.
And the only way to change yourself is by eliminating womb-envy, through COBIRTHING. In Cobirthing, a simple technique, a man simulates pregnancy and childbirth.

Enroll in a day workshop or weekend intensive at the World Cobirthing Center NOW. You will find the Cobirthing experience fulfilling and amazingly regenerative. You will enjoy a great release of tension followed by profound calmness and well-being. Connect with your inner power source and tap into blissful cosmic peace.

Testimonials

Mrs. van Eyck, Ghent, Minnesota:
"We found the Cobirthing experience both exhilarating and challenging. At first it turned our lives inside out, but now my husband is glowing with a love and serenity beyond belief. He is kinder, more compassionate and even helps with the housework!"

Crystal Rune, Fairyland, California:
"Unbelievable!"

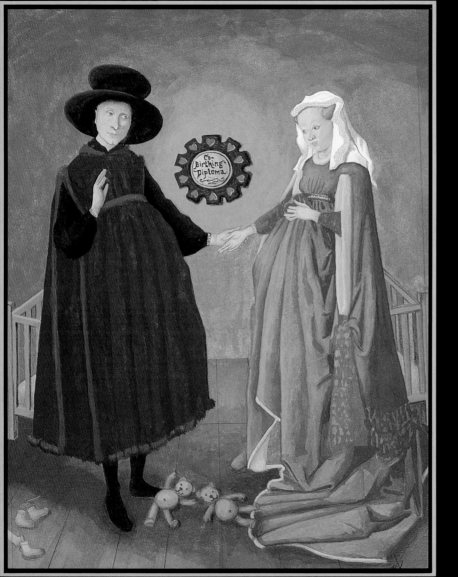

***Mrs. van Eyck
Shares the Birthing
Experience***

after Jan van Eyck's
The Arnolfini Marriage, 1434

MANTEGNA

Mantegna paints me pierced and
 martyred.
Sewing's not for folk fainthearted.

Markings on a sewing pattern
look like Greek to me. Or Latin.

At needleworking I'm not nimble.
God! It's torture with no thimble.

Wholly, I atone for sins
by cushioning these neat new pins.

My body's punctured. Just like Saint
Sebastian. I feel quite faint.

Darned bloody wounds! How I
 must suffer!
Roman martyrs were much tougher.

I meditate on how I'd feel
if stretched like Catherine on a
 wheel.

I'm relieved, though life's no lark,
I wasn't burned like Joan of Arc.

Stitching I can't cotton onto.
Maybe I don't really want to.

Mrs. Mantegna
Can't Sew

after Andrea Mantegna's
Saint Sebastian, c. 1455–60

BOTTICELLI

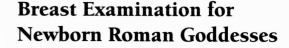

Breast Examination for Newborn Roman Goddesses

Examine breasts regularly for abnormalities.

1. In the shower. Hover on Neo-platonic designer shell. Look weightless.

2. Tilt head slightly. Look translucent.

3. Clasp exquisitely long golden hair, decorously covering pudenda. Look ethereal.

4. Adjust hot and cold taps to zephyrlike spray. Look sweet and graceful.

5. Keeping fingers together and flat, feel breast with gentle, circular motions.

6. Repeat with other breast by swapping hands, at no time revealing mound of Venus.

7. Always remember you must simultaneously idealize both classical love goddess and Christian madonna.

Mrs. Botticelli Examines Her Breasts on the First Day After Her Period

after Sandro Botticelli's
The Birth of Venus, c. 1480

DA VINCI

*M*rs. da Vinci's fantastic weight loss story:
or "Now I fit into the Slim-Trim Hoop of Perfection."

I used to be overweight, listless, about fifty-seven years old, 4'10" in height and a horrible 225 pounds—not a pretty sight. Enough to make that Mona Lisa smirk.

Since attending the Ms. Universe Slim-Trim Weight Loss Clinic I've become a slender, perfectly proportioned twenty-two-year-old Renaissance beauty. I've grown several inches in height and I take an active interest in aeronautical engineering, astronomy, philosophy, dissecting cadavers and inventing things. Last Supper, Leonardo and I invited twelve guests. We served Slim-Trim lo-cal bread and wine. Divine.

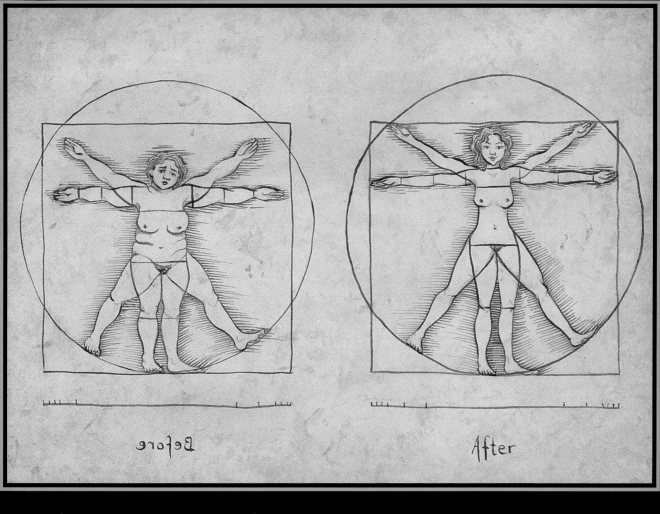

Before After

Mrs. da Vinci Loses Weight

MICHELANGELO

Poor Micky's bending over backwards,
hanging, lying, kneeling.
A genius with aches and pains, he
decorates a ceiling.

With artists' wages meager,
chiropractic bills galore,
I'm forced to trudge the skies to
sell cosmetics door-to-door.

While Micky's working overtime
embellishing the chapel,
I tempt and lure with Eve Nite Creme
and Scent of Adam's Apple.

For skin possessed by evil acne—
Blemished, scarred and spotty,
those pimples can be exorcised with
Cleanser Buonarroti.

I've Genesis Foundation for
a born-again complexion
and Essence of Creation gives
celestial perfection.

Six days a week Mick paints and I
ring doorbells. On day seven
we stay in bed, ignore the kids—
a working couple's heaven.

Mrs. Michelangelo Sells Cosmetics Door-to-Door

REMBRANDT

I've been meaning to defrost the fridge since the Renaissance, but kept getting sidetracked.

First, Rembrandt wanted me to pose as Potiphar's wife, then Susanna with the Elders, then Bathsheba and God only knows who else.

We had the Reformation and the Counter-Reformation.

Then we had to have lots of boring Puritans and rowdy Cavaliers over to dinner. *So* much cooking.

Then we fell on hard times when Rubens was doing soft-porn pictures like *Rape of the Sabine Women*, which spoiled the market for sensitive, humane portraits of mistresses.

Well, I've finally got around to defrosting the fridge.

Can't let it wait till the Enlightenment.

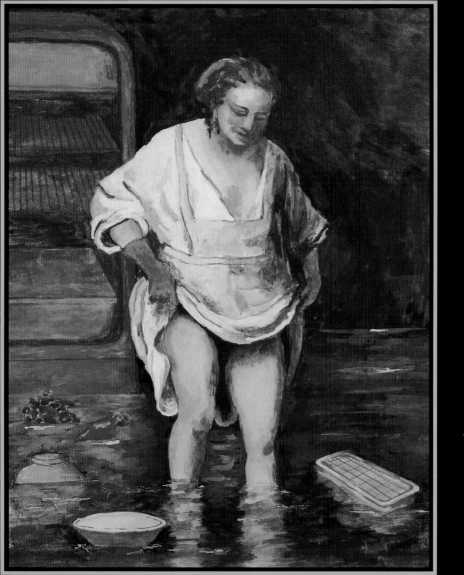

***Mrs. Rembrandt
Defrosts the Fridge***

after Rembrandt van Rijn's
Woman Bathing, 1655

BLAKE

In the beginning was the Sink. And the Sink was Shiny. And Mrs. Blake spake unto her daughters. And she saith: "Every silver lining hath a cloud. And the cloud must be scrubbed. Only New Miracle Kleenbrite penetrates the heavens, spiriting away dirt and grime. Go forth and sterilize, my children. For the squeaky clean shall inherit the earth."

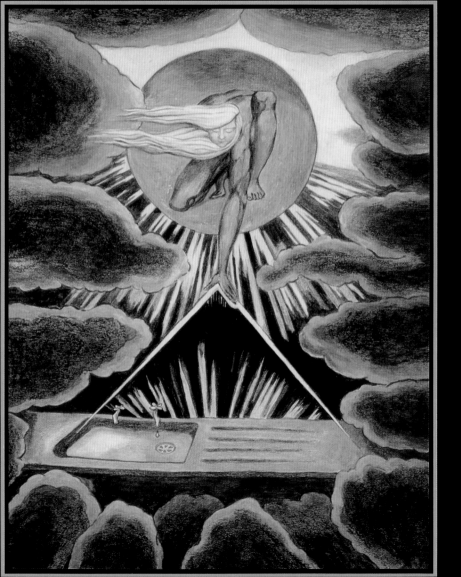

Mrs. Blake Worships New Miracle Kleenbrite

after William Blake's *The Ancient of Days*, metalcut with watercolor, 1794

DAVID

The work of Jacques that all revere
is neoclassically austere.

While I indulge in my ablutions,
Jacques paints oaths and revolutions—

compositions noble, bold,
but boringly precise and cold.

Jacques' *réalisme* is pedantic.
Je préfère un homme romantic.

Jean-Paul Marat—*il est mon cher.*
We're having *une petite affaire.*

While in the bathtub I relax
Marat declares his love by Fax.

Luxuriating in the tub,
I find some dark red stains to scrub.

My pleasure's ruined by this chore.
What *is* this mess upon the floor?

Mon dieu! I see that blood was shed.
Marat, my hero, are you dead?

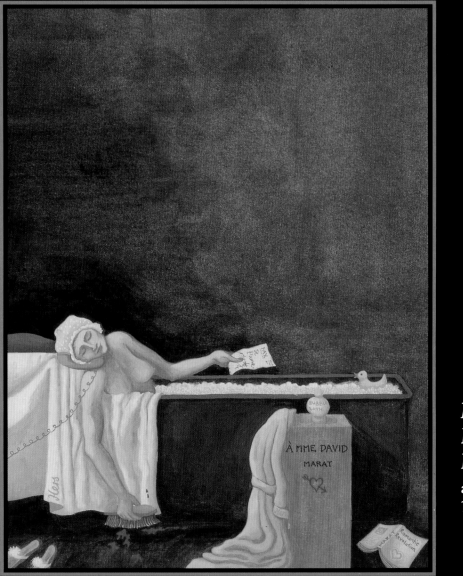

Mrs. David
Luxuriates in the
Bath

after Jacques Louis David's
The Death of Marat, 1793

INGRES

**Yoga Sanitissana
or "Domestic Yoga"**

**is yoga for health, beauty
and a sparkling house.**

*T*ts repetitive rhythms reflect the endless circularity of housework—sedating, meditative.

The yoga posture (asana) of *Nookancrannasana*, commonly known as "*the Duster*" or "*Spineless Twist*," has many benefits e.g. :

- provides good stretch for the back
- keeps you supple and spongy
- helps you reach those hidden crevices that gather dust

Instructions

1. Start with cleansing breath to rid yourself and your house of impurities. Remember, *in*hale beautiful fresh disinfected energy and *ex*hale toxins.
2. Entwine legs.
3. Place right hand on left upper arm.
4. Place left hand on right thigh, or is it left?
5. Slowly twist spine until looking self-consciously over right shoulder toward viewer.
6. Inhale. Dust. Exhale. Dust.
 Inhale. Dust. Exhale. Dust.

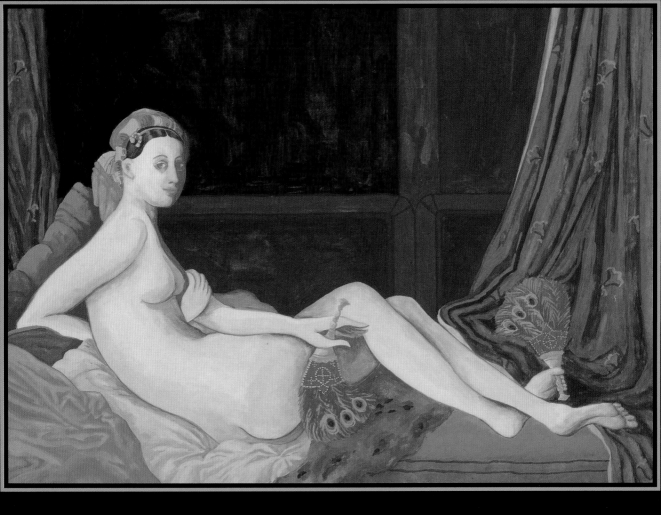

Mrs. Ingres Enjoys the Yoga of Dusting

TURNER

Joseph and I have just been through a stormy patch.
He gets caught up in a swirling vortex of work. So tempestuous.
This morning he tried to lighten the atmosphere with breakfast in bed.
He's a real romantic at heart. Of course, he burned the toast. What can one expect with a *man* pitted against the element.
Smoke everywhere. I was fuming.
Must stop gasbagging. It's full steam ahead with the chores.

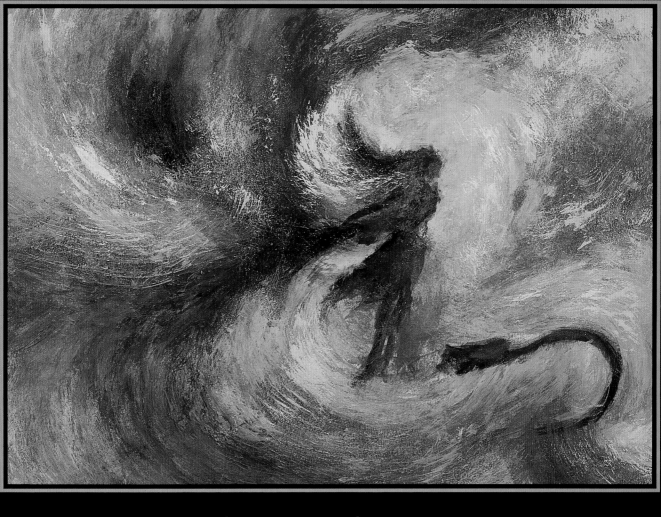

Mrs. Turner Empties the Vacuum Cleaner

after Joseph Mallord William Turner's

MILLET

OK—welcome to Wednesday Gleanaerobics.

We're here to work out and GET FIT. Right hand to the ground....

Yeah!... Flex those biceps.... Grip those handweights.... Ooh.... Feel that terrific stretch....

That's it.... Capture a bit of that "hero of the soil" flavor....

Come on, girls, see if you can strike a monumental pose against the flat, dull landscape and glorify even the humblest rural folk....

Tighten those buttocks, pull in those tums... and bend and bend and glean and glean....

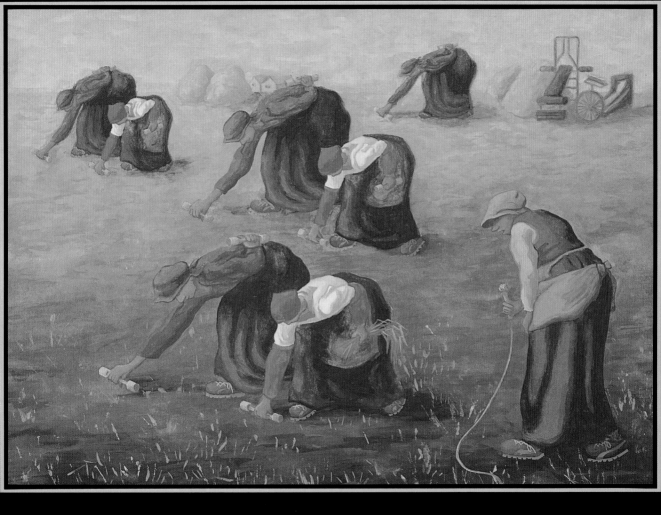

Mrs. Millet Attends a Fitness Class

WHISTLER

Neighborhood Watch is loads of fun.
I ogle, peer and peek
at B-grade dramas starring all
my neighbors through the week.

I have no need for video.
I unplugged my TV.
Each morning I just hoist the blind
to see what I can see.

Young Mrs. T.'s a prostitute.
Her grandad deals in dope.
The kiddies gamble on the dogs.
Who needs a boring soap?

I like domestic violence.
A slap, a scream, a bruise,
a good old wallop in the jaw's
more shocking than the news.

Of bedroom antics neighborly
my eyesight never wearies.
I wasn't quite as satisfied
by any mini-series.

This show has universal themes.
It's riveting and timeless.
I hope I never move into
a neighborhood that's crimeless.

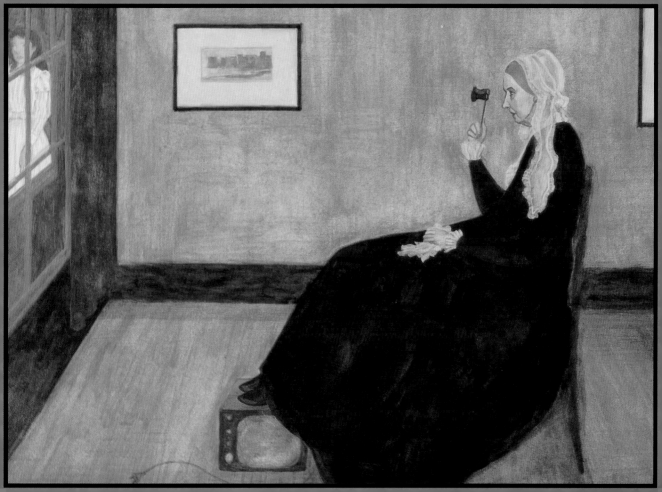